BATH
HISTORY TOUR

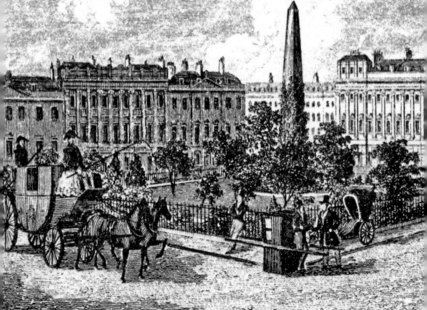

ACKNOWLEDGEMENTS

I am very grateful to the following people and organisations for their kind permission for the reproduction of photographs in this guide, which were used in my *Bath Through Time* book published in 2012. The majority of the photographs and illustrations are my own.

My thanks go to Marcus Pennington and Nick Grant of Amberley Publishing; Stuart Burroughs, Director of Museum Bath at Work, Julian Rd; Patrick McGuire of the Royal Hotel, Manvers Street, Bath; Jonathan Stapleton, general manager of the Royal Crescent Hotel; St James Wine Vaults, No. 10 St James' Street; Martin Salter of the Jane Austen Centre; Sally Lunn's Tearooms; and local artist Malcolm Purvis. Last, but by no means least, Guy Parfitt for encouragement, research and photographs.

First published 2018

Amberley Publishing
The Hill, Stroud,
Gloucestershire, GL5 4EP
www.amberley-books.com

Copyright © Jenny Knight, 2018
Map contains Ordnance Survey data
© Crown copyright and database right
[2018]

The right of Jenny Knight to be identified as the Author of this work has been asserted in accordance with the Copyrights, Designs and Patents Act 1988.

ISBN 978 1 4456 7889 4 (print)
ISBN 978 1 4456 7890 0 (ebook)

British Library Cataloguing in Publication Data.
A catalogue record for this book is available from the British Library.

Origination by Amberley Publishing.
Printed in Great Britain.

INTRODUCTION

My book *Bath Through Time*, published in 2012, drew upon a number of photographic collections, both old and new, and now in 2018 I am very pleased to reissue some of them to give new visitors a tour of the historical sites of our wonderful World Heritage City.

In *Bath History Tour*, the reader can follow a route around the city starting at the Royal Crescent, a row of thirty terraced houses designed by John Wood the Younger between 1767 and 1774. The walk finishes at the bottom of Milsom Street, our main shopping area, after a whirlwind sweep through the city streets, walkways and buildings.

Each year, tourists come to Bath and are shown the hidden treasures by the Mayor's City Guides. I hope *Bath History Tour*, in a similar way, gives you a snapshot of our city's historical story, through a selection of illustrations and photographs.

I hope you enjoy your exploration of Bath, and that as you travel and sift through the pages you find it a useful guide, one that adds joy to your visit and a practical road map that helps you find your way around arguably England's most beautiful and charming city.

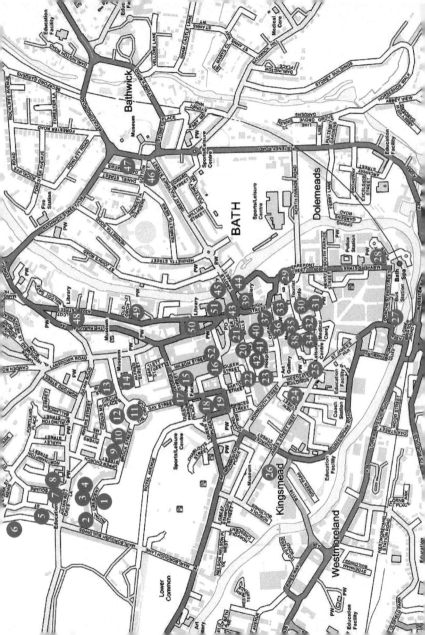

KEY

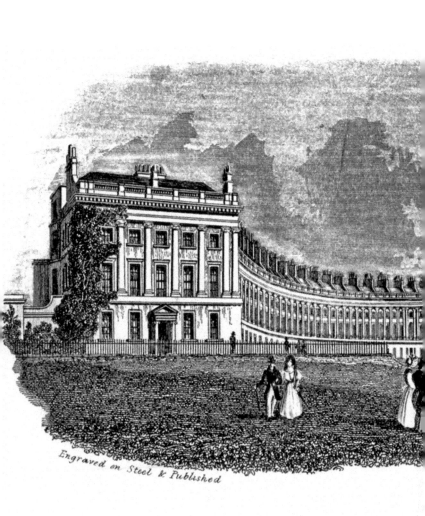

Engraved on Steel & Published

THE ROYAL CI

1. FRONT OF THE ROYAL CRESCENT

Our history tour starts here, along from Brock Street linking with the Circus, at the world's finest crescent showing the entire thirty town houses designed by John Wood the Younger between 1767 and 1774. In the engraving by J. Holloway the ha-ha can be seen (a step down from the lawns, which was to keep the grazing sheep away). The façade is exquisite, but the backs of the buildings were not seen as important, so were more functional.

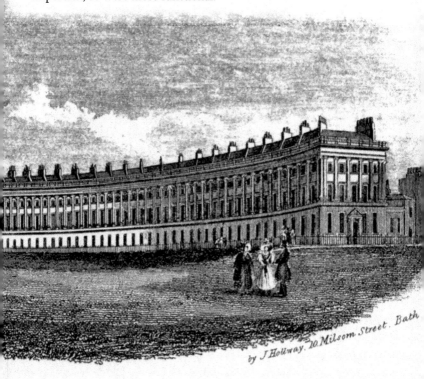

by J. Holloway. 10. Milsom Street. Bath

2. EVENTS IN THE ROYAL CRESCENT

In May 2012 crowds gathered in the warm weather to watch the Olympic torch pass through the city streets. Bath Music Festival in May is a highly celebratory event with an eclectic selection of musical highlights around the city.

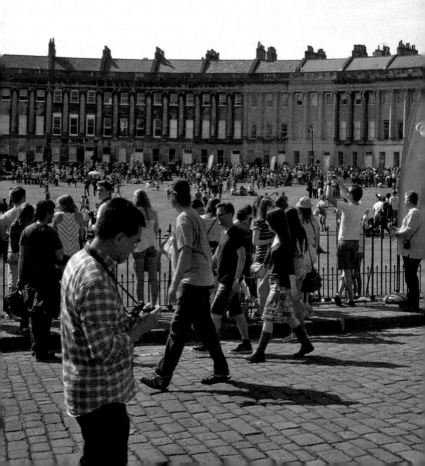

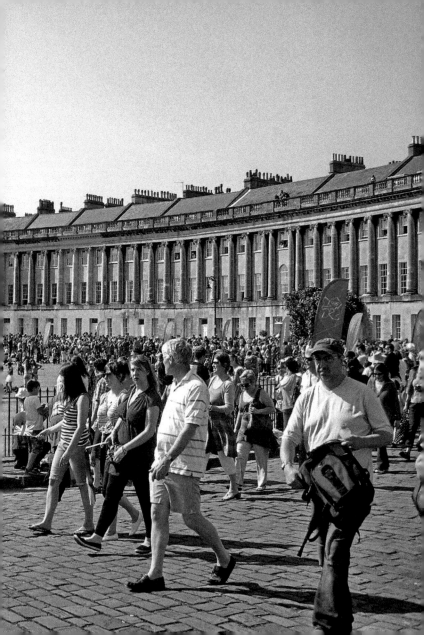

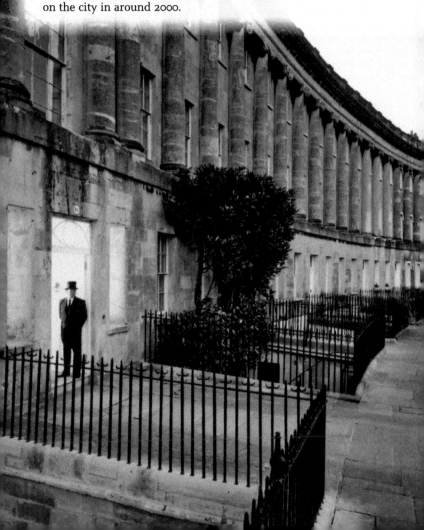

3. THE ROYAL CRESCENT HOTEL

No. 16 Royal Crescent is a hotel and one of Bath's best-kept secrets. A concierge stands on duty ready to welcome guests as the sun sets on the city in around 2000.

4. THE ROYAL CRESCENT HOTEL GARDENS

Arguably the best address in Europe, here the stunning gardens behind the façade lead to the Dower House. This would have housed coaches but is now home to an elegant restaurant, bar and additional bedrooms. To the left out of shot there is a Japanese-style spa. The hotel is renowned for its afternoon teas – do stop for one!

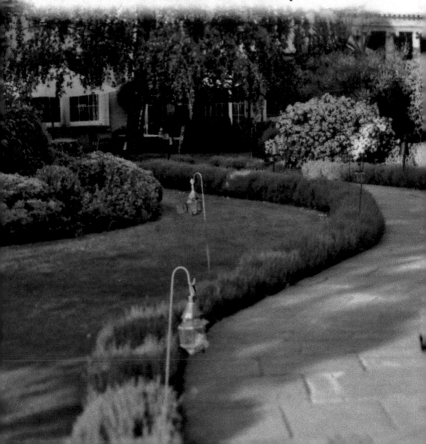

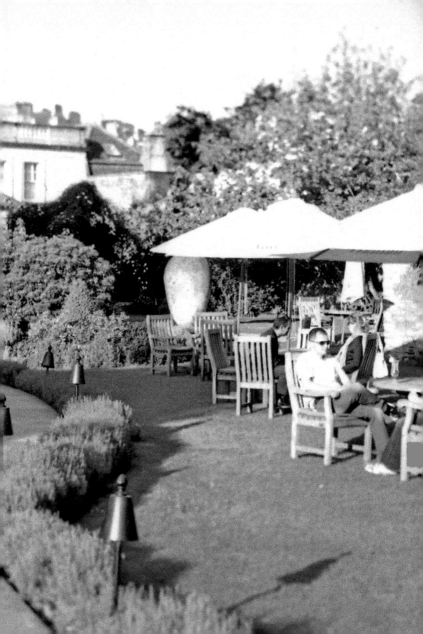

5. CAVENDISH ROAD

Cavendish Road leads towards Sion Hill and Lansdown Crescent, and the town houses – which are now elegant flats – provide a wonderful vantage point, with balconies on the first floor. The green fields in this illustration, next to where the carriages drove, provided grazing land for cattle.

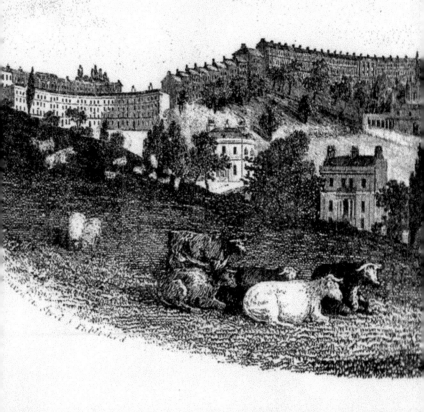

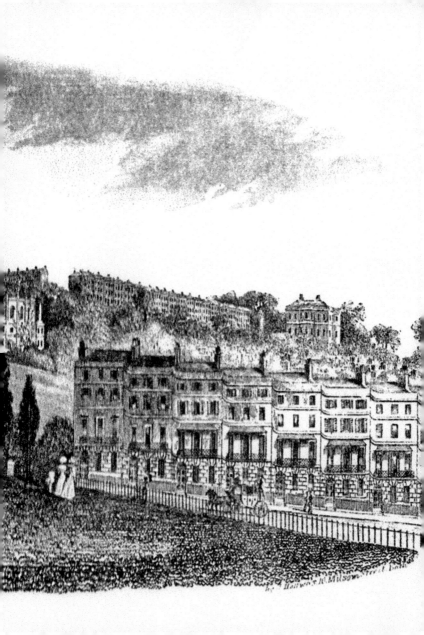

by Holway, 10 Milsom Street, Bath.

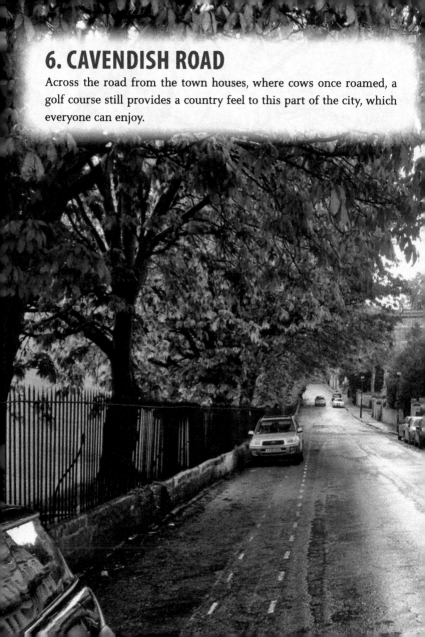

6. CAVENDISH ROAD

Across the road from the town houses, where cows once roamed, a golf course still provides a country feel to this part of the city, which everyone can enjoy.

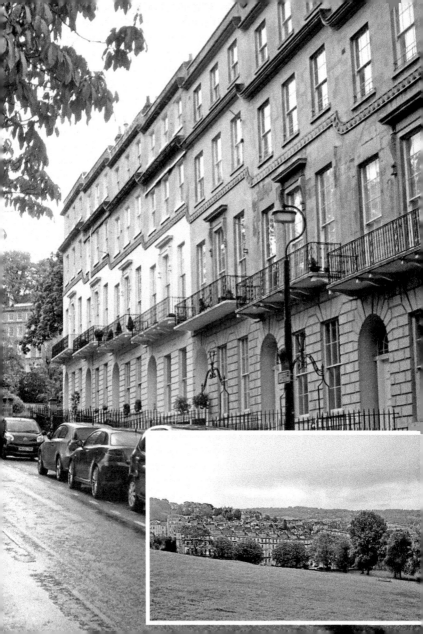

7. ST JAMES WINE VAULTS

This sign is around the corner from the St James Wine Vaults in St James's Street leading to the attractive St James's Square. On the back wall, high up, you can see the old Ushers advertisement for the St James Wine Vaults and Bar. In the foreground is the attractive Crescent Flowers shop on Crescent Lane, Julian Road, opposite the rear entrance to the Royal Crescent Hotel, as seen in the photograph on page 19.

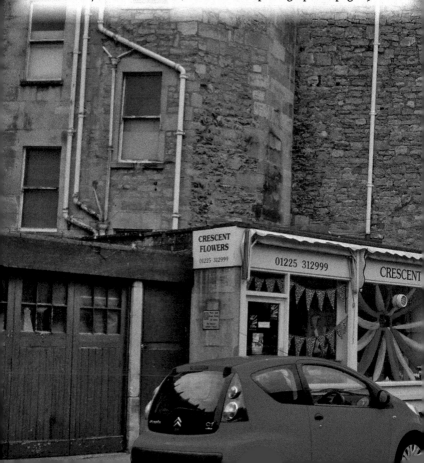

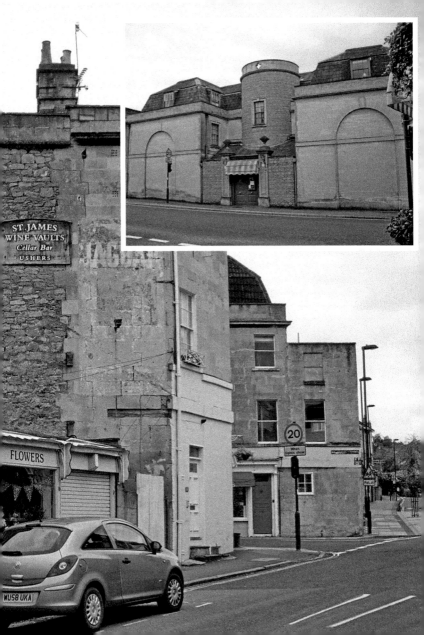

S'T JAMES

WINE VAULTS

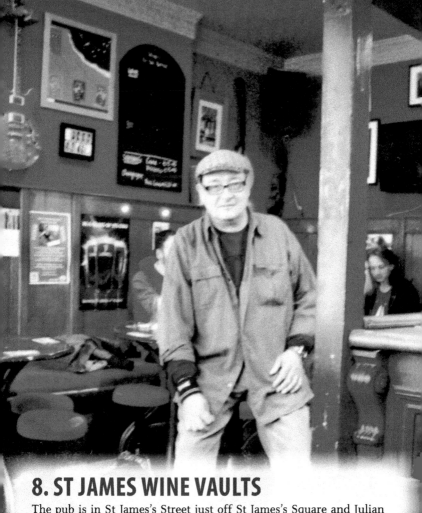

8. ST JAMES WINE VAULTS

The pub is in St James's Street just off St James's Square and Julian Road. The old pub sign now hangs on one of the walls inside the pub. Michel Beaugeard, pictured in 2012 and originally from France, was a former head chef for the famous Beaujolais restaurant once situated in Queen Square and which started the annual Bath Boules competition.

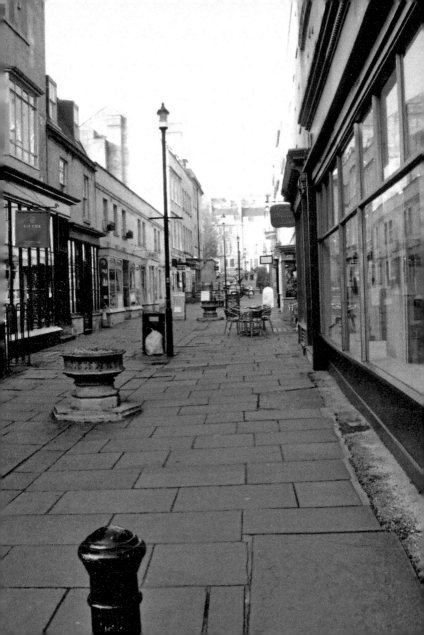

9. MARGARET'S BUILDINGS

Margaret's Buildings is still a busy thoroughfare of stylish shops, a launderette, a hairdressers, restaurants and a few art galleries. On the right beyond the Italian bistro is Heavens Bazaar, a stylish vintage clothes and accessories shop frequented by enthusiasts from around the world. Beyond the walkway is Catharine Place and Rivers Street.

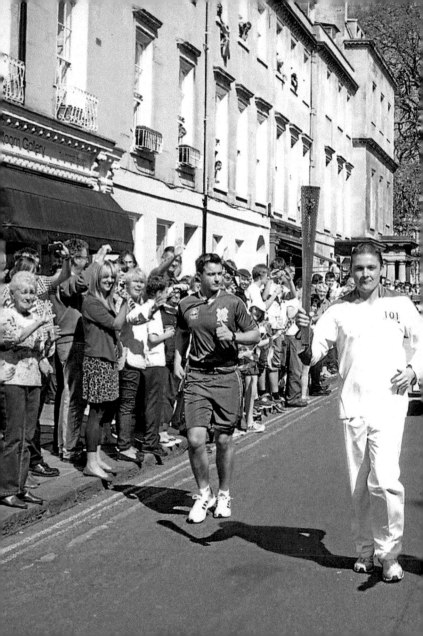

10. BROCK STREET

Brock Street links the Royal Crescent with the Circus. In the picture, Chris (No. 101) ran with the Olympic torch down Brock Street towards the Royal Crescent in May 2012 before the London Olympics took place. Crowds lined the road to cheer him on.

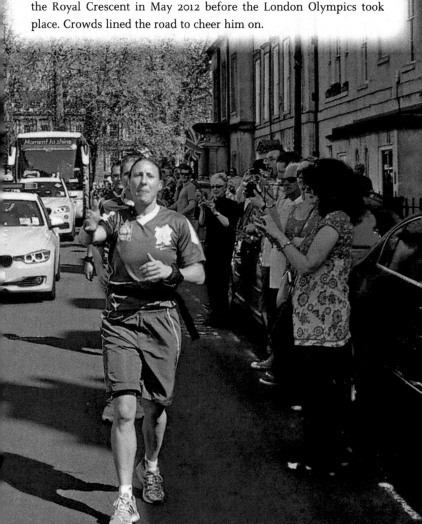

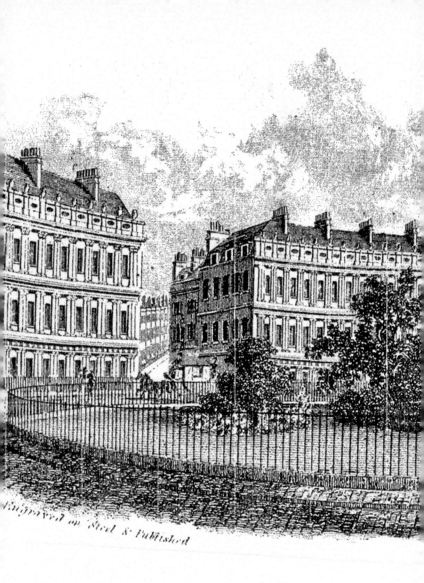

THE CI

11. THE CIRCUS

Completed in 1768, it was originally called the King's Circus and was designed by John Wood the Elder. Divided into three equal sections of town houses, the buildings are Palladian in their architectural style. The railings in this picture are no longer there, having been removed to be reused in the Second World War.

by J. Hollway, 16 Milsom St

US. BATH.

12. THE CIRCUS

Several well-known residents have lived in the Circus. During the latter 1700s the famous painter Thomas Gainsborough lived at No. 17 and had a portrait studio there. This picture, taken in May 2012, shows the crowds awaiting the arrival of the Olympic flame.

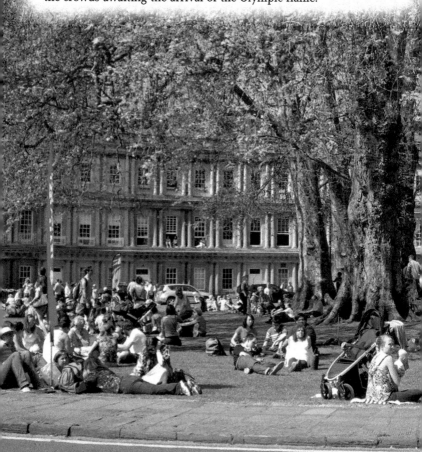

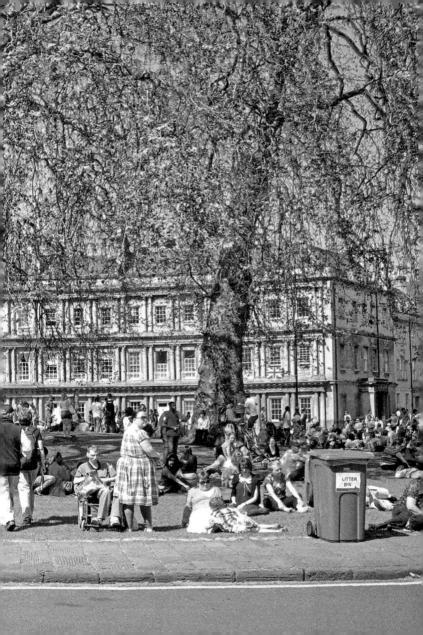

13. ASSEMBLY ROOMS AND TOURIST BUS

Tourists in Bath have the 'hop on, hop off' tour bus guide around the city's attractions. The Assembly Rooms opened in 1771 and were known as the New or Upper Rooms. They were designed by John Wood the Younger. Inside are exquisite chandeliers made by Whitefriars in London, and they are the finest set of eighteenth-century chandeliers in the world.

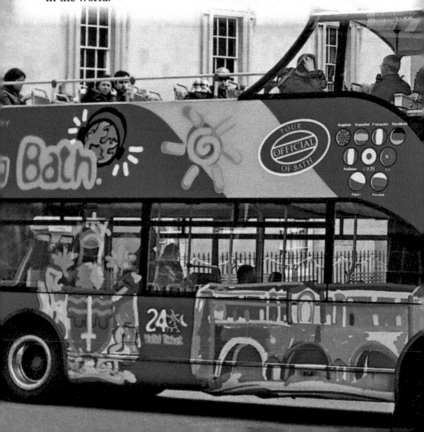

14. ASSEMBLY ROOMS

The photograph shows the front entrance of the Assembly Rooms today. The Assembly Rooms were a gathering point for Georgian balls and public functions, which were mentioned by writers Charles Dickens and Jane Austen, who both lived in Bath for a time. Today the rooms are still used for events and also house a wonderful Museum of Costume.

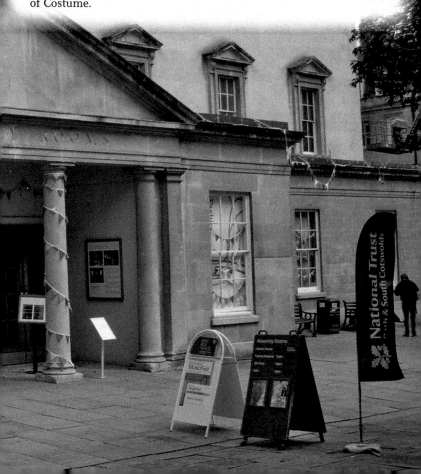

15. MILSOM STREET

Milsom Street, built in 1762, is shown here from the bottom of the street looking north towards George Street. Notice how the grand homes of yesteryear have been turned into shopfronts; most are now Grade I listed and have three storeys. The photograph, taken in 2012, shows the jewellers Goldsmiths in the left-hand corner, which is no longer there. Other shops have changed and the new Ivy restaurant is halfway up on the right, where a bank used to be.

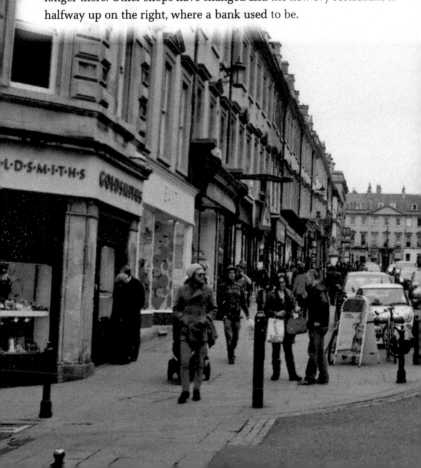

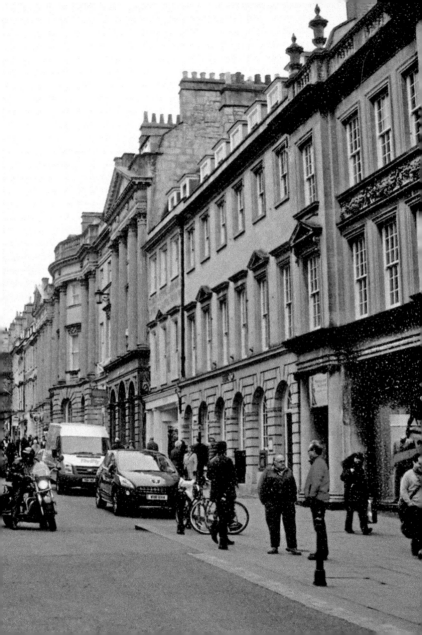

16. THE RAVEN PUB

Time for a drink? The Raven pub, situated at No. 7 Queen Street, is said to comprise of two Georgian town houses. It was the meeting place for those interested in publishing and was previously known as Hatchetts. Later the building was H. R. Fuller wine merchants until the 1930s.

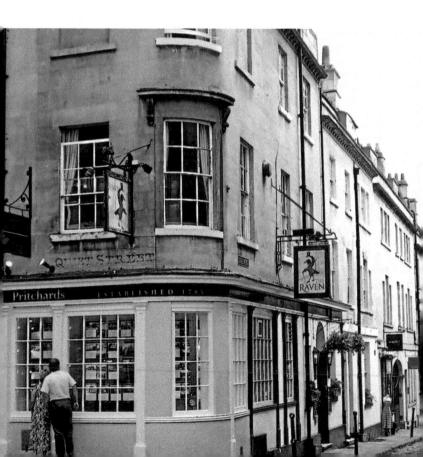

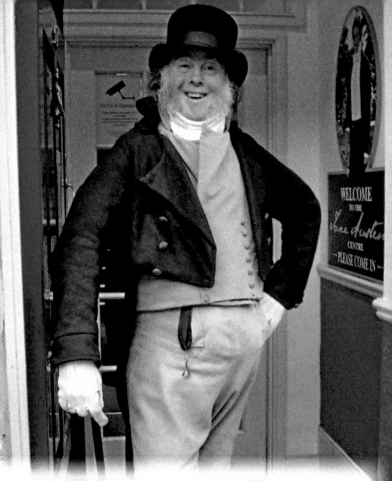

17. JANE AUSTEN CENTRE

Martin Salter, possibly the most photographed man in Bath, is dressed here in his Georgian finery. Visitors to the city often take snaps of him standing outside the Jane Austen centre. Inside the centre is a museum and shop dedicated to the writer, and is situated at No. 40 Gay Street, just above Queen Square.

18. QUEEN SQUARE

Queen Square was designed by architect John Wood the Elder, who lived on the square. The obelisk constructed in 1738 was erected by Bath's Master of Ceremonies Beau Nash. The 1858 drawing shows people promenading the wide pavements and carriages being pulled along either by hand or by horse.

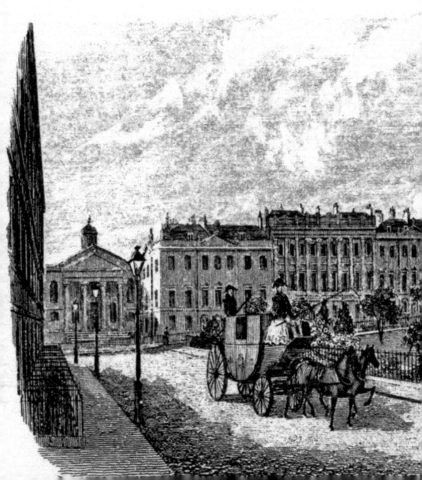

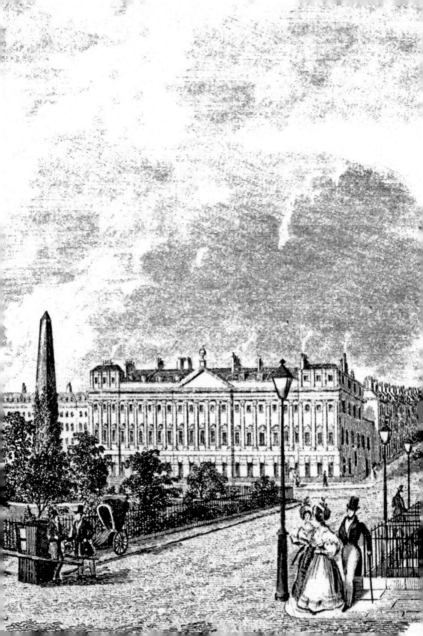

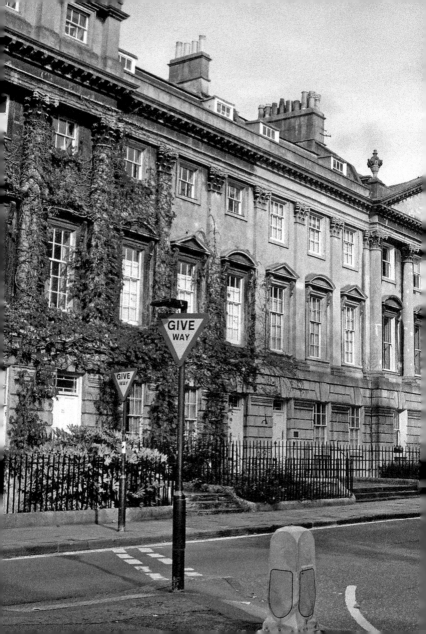

19. QUEEN SQUARE

The façade of the top end of Queen Square is still intact but few are complete homes anymore, as most are divided into flats and offices. The square is home to local events and an annual boules competition between local businesses all vying for a trophy.

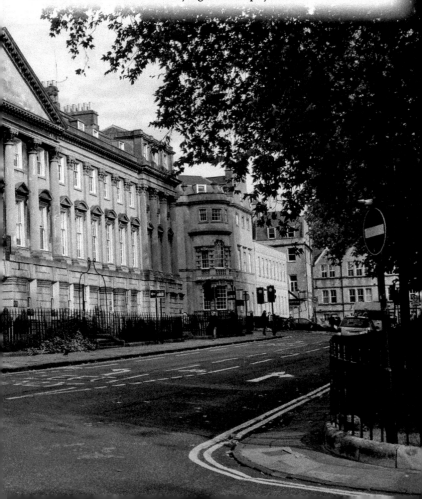

20. UPPER BOROUGH WALLS

Upper Borough Walls is a historic street that takes its name from the section of the medieval wall of the city that still remains. Opposite is the Mineral Hospital.

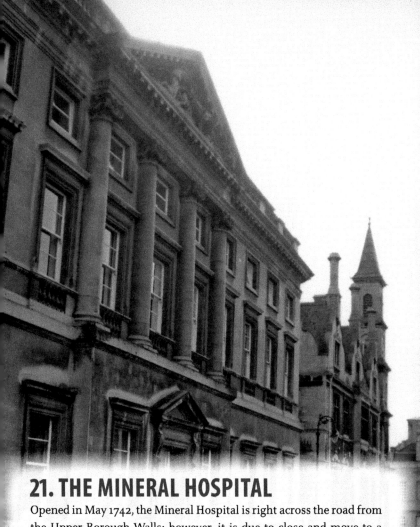

21. THE MINERAL HOSPITAL

Opened in May 1742, the Mineral Hospital is right across the road from the Upper Borough Walls; however, it is due to close and move to a new home at the Royal United Hospital, Bath. The hospital has always been an important centre for the treatment of rheumatic diseases.

22. THEATRE ROYAL

The front entrance of the Bath Theatre Royal was refurbished in 2010. It is over 200 years old and can hold an audience of up to 900 people. John Palmer (1742–1818) became owner of the Theatre Royal during the 1770s. Palmer also developed an efficient national postal service and the first penny black was sent from Bath.

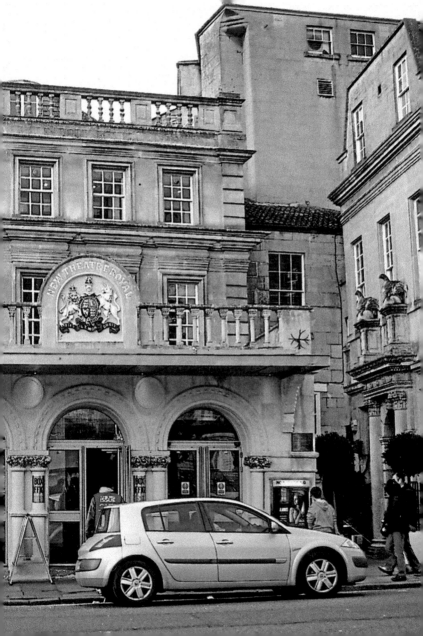

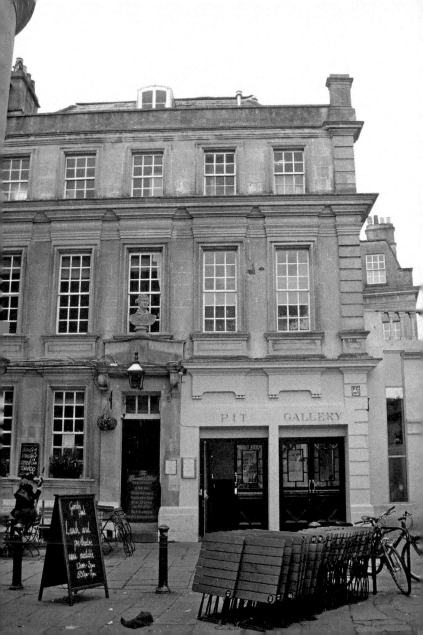

23. GARRICK'S HEAD

The pub attached to the Theatre Royal, Saw Close, takes its name from the eminent actor David Garrick (1717–79), who had a lasting impact on English theatre during the 1830s. The pub attracts theatregoers and actors alike, and is situated between the Egg Theatre and the Theatre Royal. Blue Coat House is no longer a school and has been upgraded recently into apartments. It is opposite the Theatre Royal and the Garrick's Head, as you can see in the picture on the right.

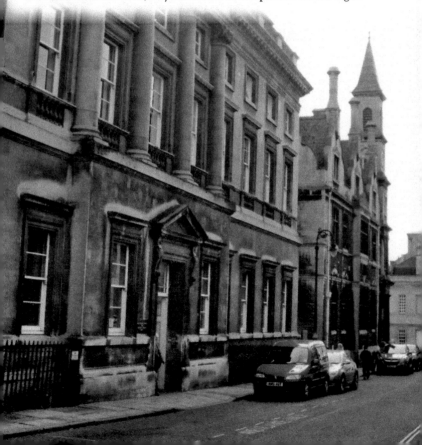

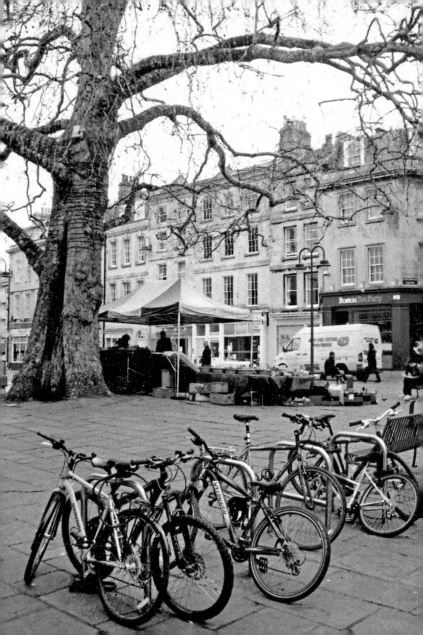

24. KINGSMEAD SQUARE

The square is a hub of activity with a fruit market, bicycle park, cafés and restaurants. On the far left of the picture is the edge of Rosewell House. This baroque-style building was built for a Mr T. Rosewell in 1736 by John Strahan – hence you can find a rose and a well on the façade. There are now shops and cafés on the ground floor.

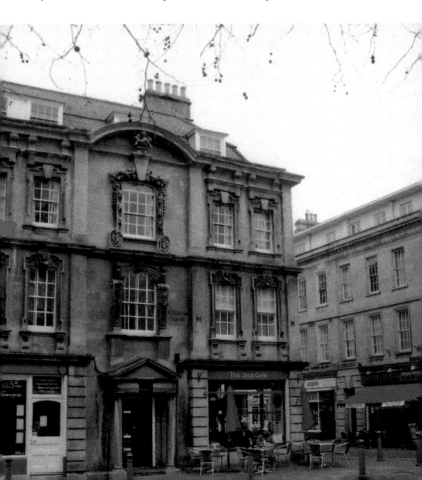

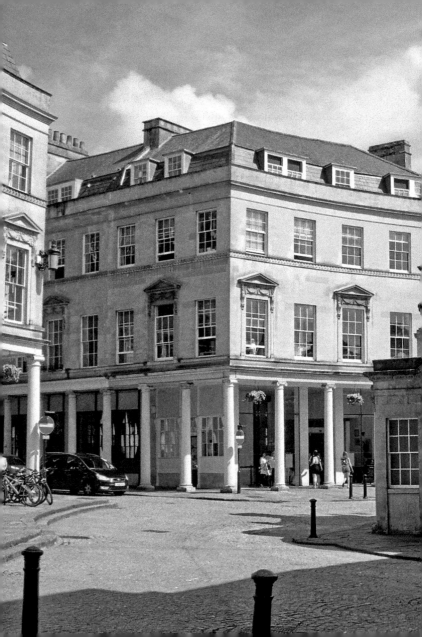

25. CROSS BATHS

The circular building in the foreground was built upon a spring and honours the goddess Minerva. It was said to have been used by those with leprosy in medieval times. Still used today, the Bath Thermae Spa building can be seen in the background (the building with the columns). On the right in the distance, what was once the Bath College is now the Gainsborough Hotel.

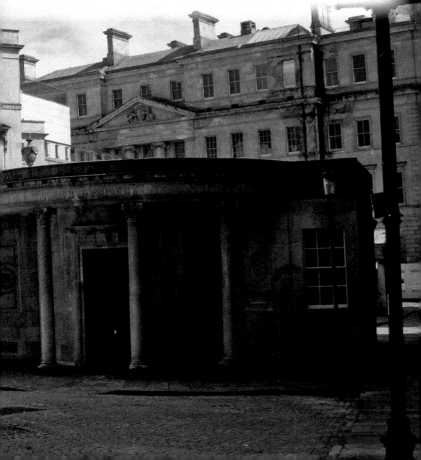

26. GREEN PARK STATION

Originally called the Queen Square station, Green Park station was opened in 1870 and **fitted** in with the Georgian style of the city buildings. It closed **following the** Beeching Report **and** passenger trains stopped from **1966, although goods trains continued** until 1971. Green Park, as it is **now known, has become a** retail area with a car park, supermarket, **brasserie, events space and a** farmers' market.

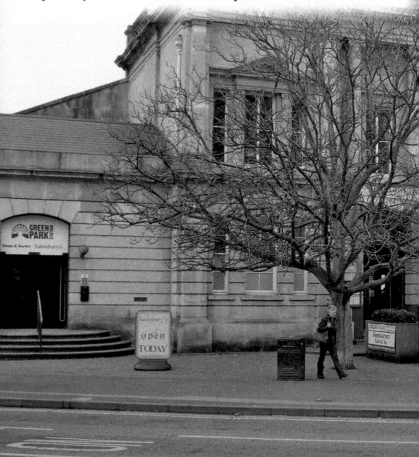

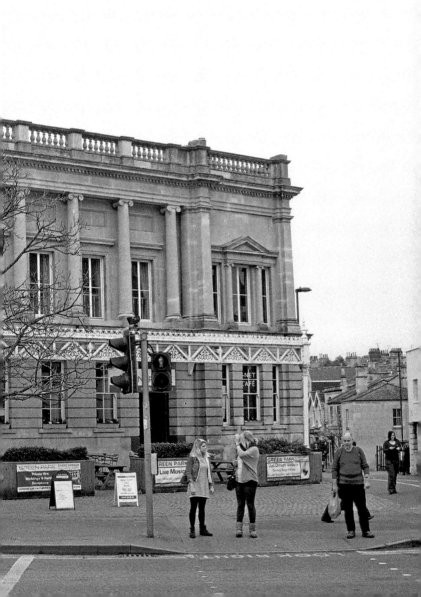

27. BUS STATION

This landscape shows the recent Southgate development in the distance. A walkway now crosses the river as a new bridge, renamed Churchill Bridge, which was moved west around 50 yards near to where the Full Moon Hotel once was – this became an elegant electrical showroom but today it is the site of the new bus station.

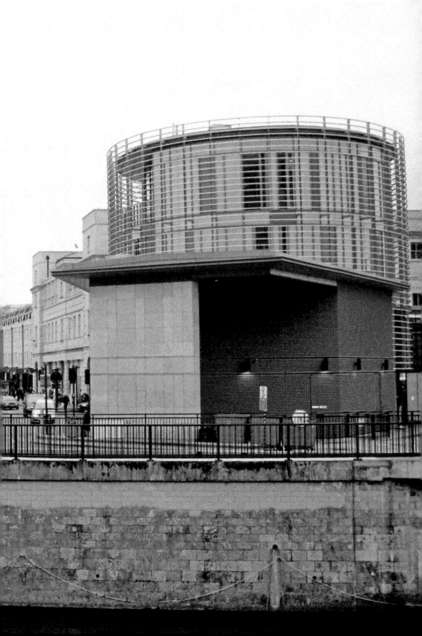

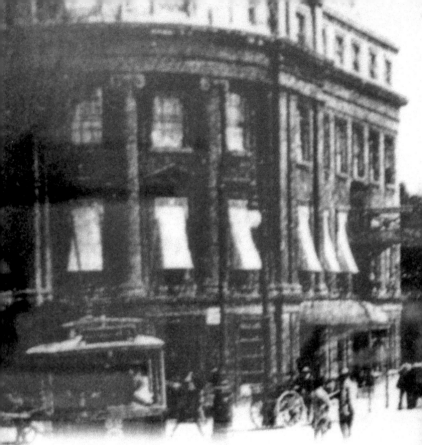

28. RAILWAY STATION

The Royal Hotel around 1900 with the pretty window awnings to the left and a walkway leading from the hotel to the train station on the right. Notice the tram and tramlines on the left of the picture. The horses and carts, although still in use, were becoming eclipsed. The inset photograph of 2012 is taken where the walkway used to be, looking down Dorchester Street with the Royal Hotel on the right and the station being refurbished.

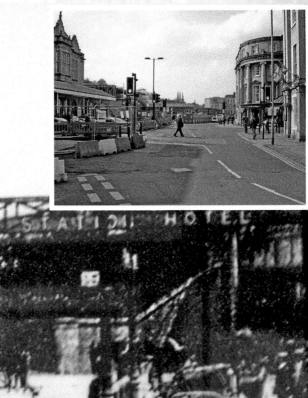

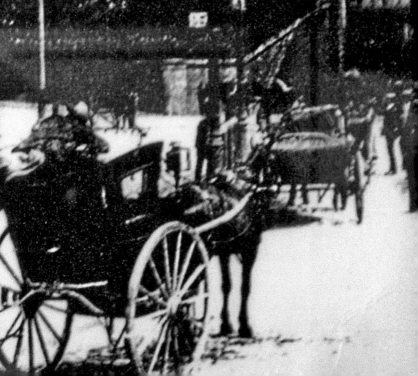

ROYAL STATION HOTEL

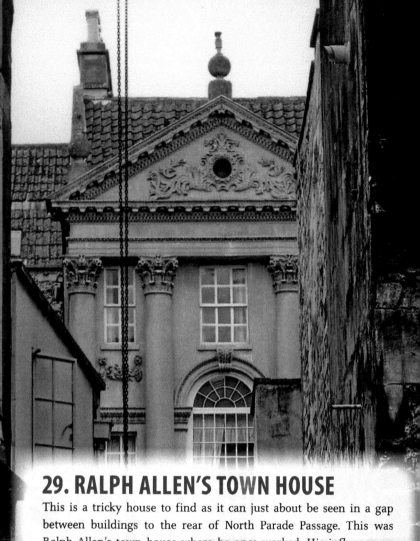

29. RALPH ALLEN'S TOWN HOUSE

This is a tricky house to find as it can just about be seen in a gap between buildings to the rear of North Parade Passage. This was Ralph Allen's town house where he once worked. His influence on Bath was immense. It was said that in order to see his impressive Prior Park home while at work he had this town house built.

30. SALLY LUNN'S

This very old picture shows what is believed to be the shopfront of Sally Lunn's, although the date is unknown. The foundations indicate the ground dates back to Roman times.

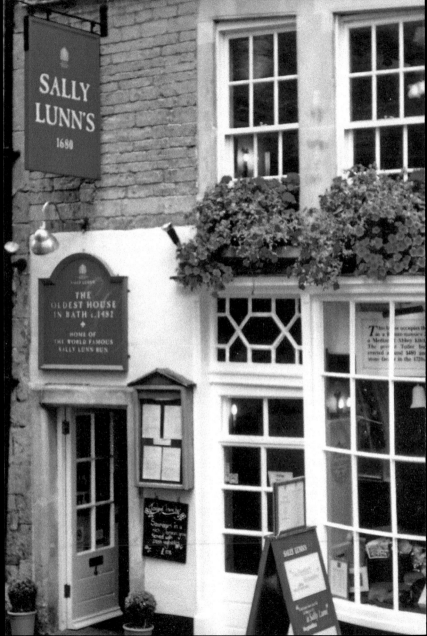

31. SALLY LUNN'S

Sally Lunn's is one of the oldest buildings in the city; the Roman and medieval foundations can still be seen in the basement. Visitors can view the ovens used by the Huguenot baker Sally Lunn, who created the world-famous Bath bun. The recipe is still a safeguarded secret by the current owners. The image on the right shows the plaque on the wall giving the date of the building as 1482.

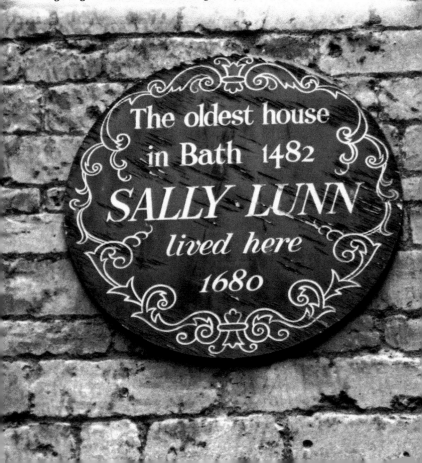

The oldest house
in Bath 1482
SALLY LUNN
lived here
1680

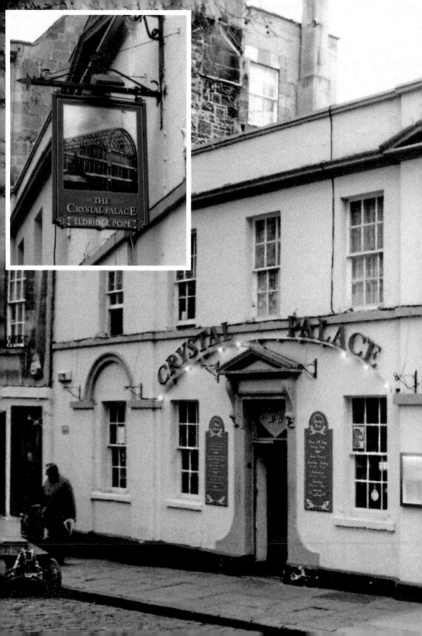

32. CRYSTAL PALACE

The Crystal Palace was previously known as the Three Tuns. Skeletons and a Roman mosaic were found underneath the cellar during renovations in the 1980s. It is suspected that the pub may rest on the site of a Roman Villa. *Inset*: The sign commemorates the Crystal Palace in London, which was a benchmark of British Victorian ingenuity.

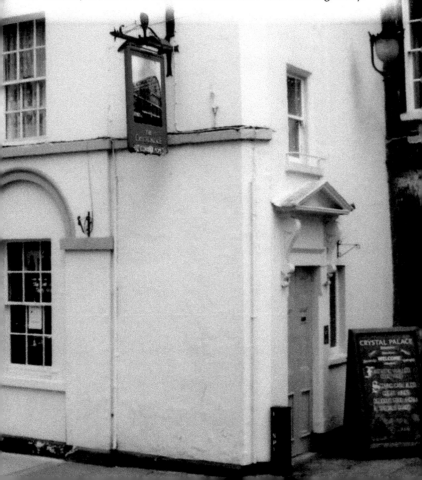

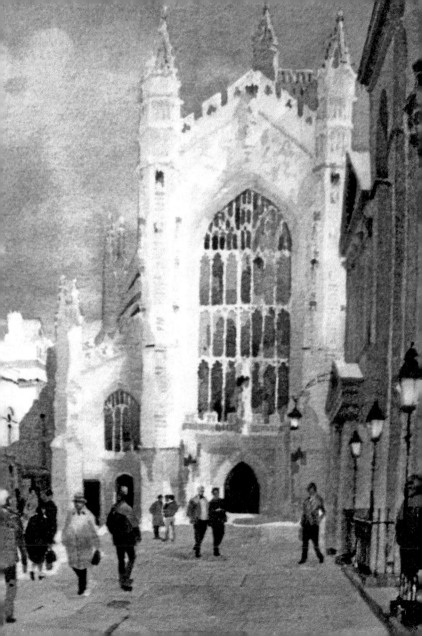

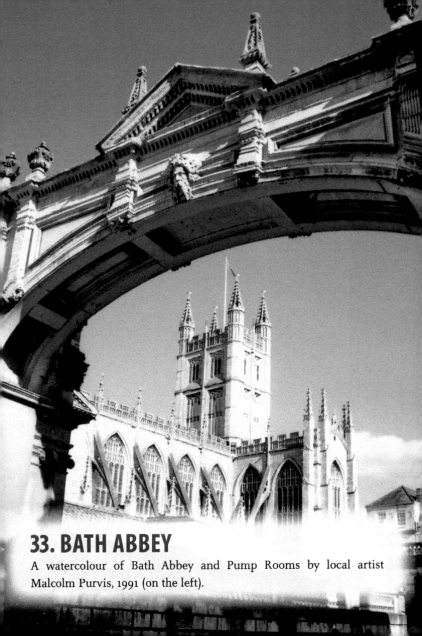

33. BATH ABBEY

A watercolour of Bath Abbey and Pump Rooms by local artist Malcolm Purvis, 1991 (on the left).

S THERMAE BATH SPA

Victoria Art Gallery

Guildhall Market

The Jane Austen Centre

William Herschel Museum

Bartlett Street
Antiques Centre

Assembly Rooms and
Museum of Costume

Railway & Bus Stations

Bath Shopmobility

Abbey Heritage Museum

Tourist Information Centre

34. KING'S AND QUEEN'S BATHS

The entrance to the King's and Queen's Baths are shown here with a view from Stall Street taken in 2003, showing the signposts to the city's attractions.

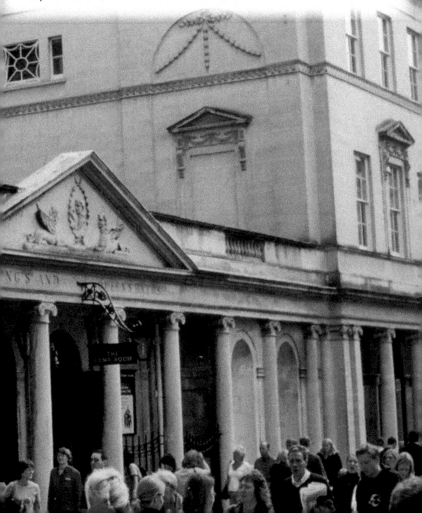

35. THE ROMAN BATHS

The Roman Baths draw vast numbers of visitors every year but the bathing stopped around fifty years ago for health reasons. There is an interesting museum here explaining the history and a shop to browse.

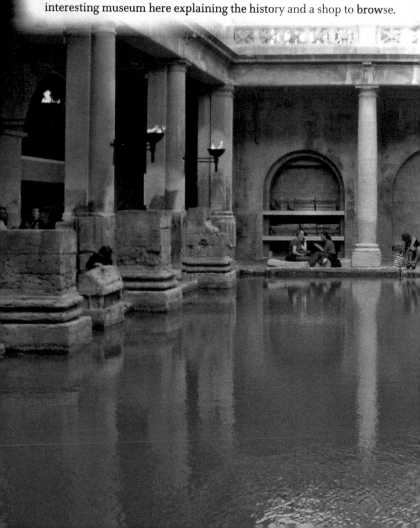

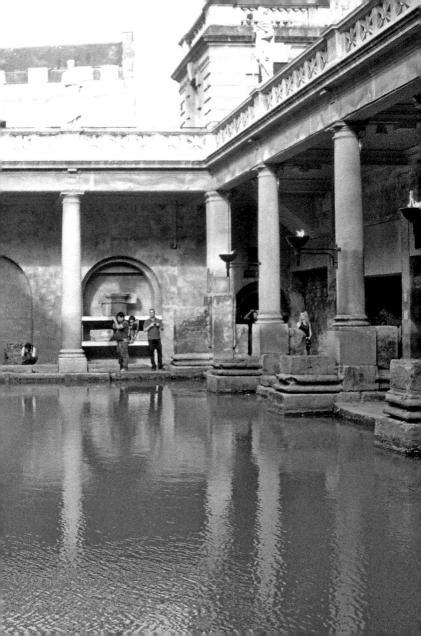

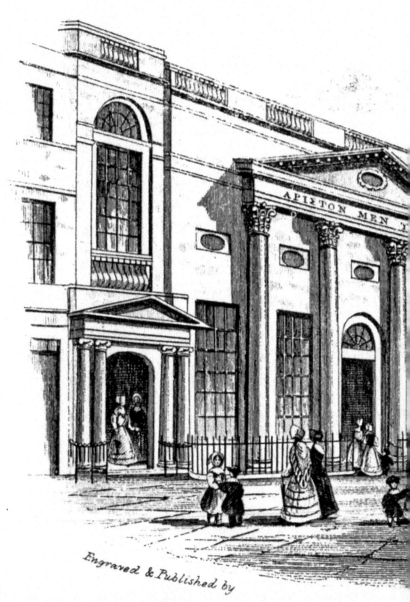

ΑΡΙΣΤΟΝ ΜΕΝ

Engraved & Published by

36. GRAND PUMP ROOM

In Georgian times the Pump Room was a meeting place for gentlemen who came for breakfast. This old sketch of the Pump Rooms by J. Holloway shows genteel, well-dressed people socialising. The building on the far right through the balustrades was once a hotel but is now a row of shops.

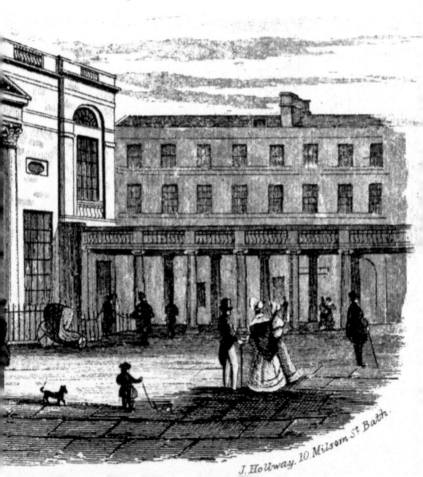

J. Holloway, 10, Milsom St Bath.

37. PUMP ROOMS

Afternoon tea was often accompanied by a musical quartet in this elegant setting, which also hosts receptions, talks and dances. This wedding car, a 1940s American Buick, waits outside the Pump Rooms entrance in around 2002. *Inset*: Wedding guests and tourists congregate outside Bath Abbey after the wedding of Mr and Mrs Kent-Lemon in July 2011.

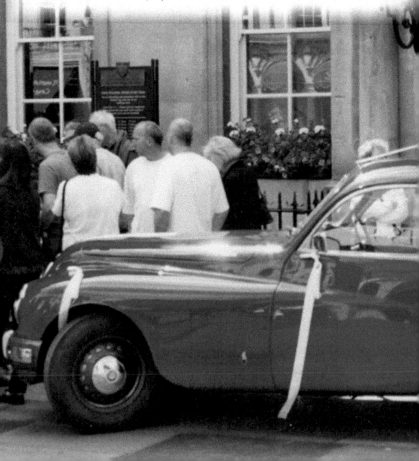

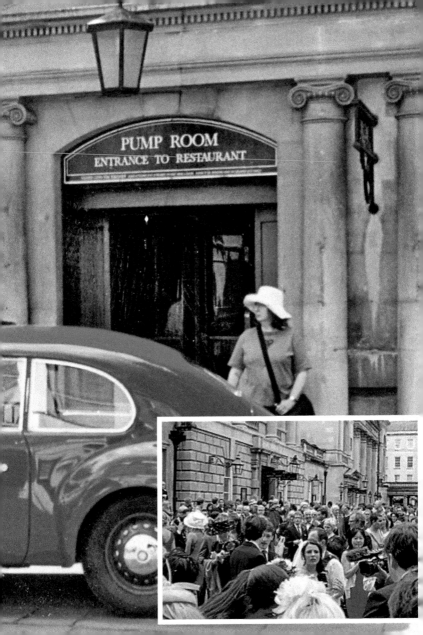

PUMP ROOM
ENTRANCE TO RESTAURANT

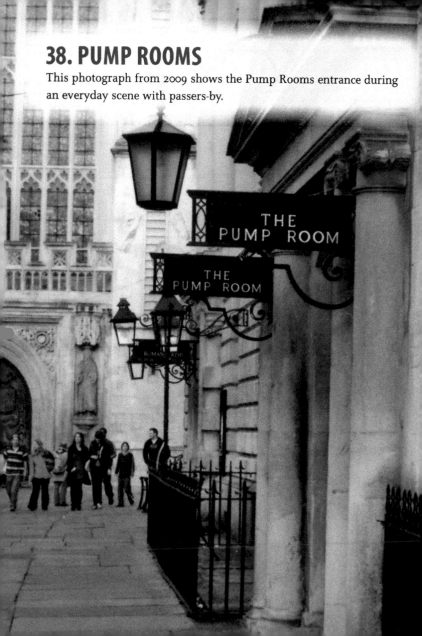

38. PUMP ROOMS

This photograph from 2009 shows the Pump Rooms entrance during an everyday scene with passers-by.

39. GUILDHALL AND MARKET

The façade of the market has not changed much over the years. Inside the market are various stalls and shops that hark back to a bygone era.

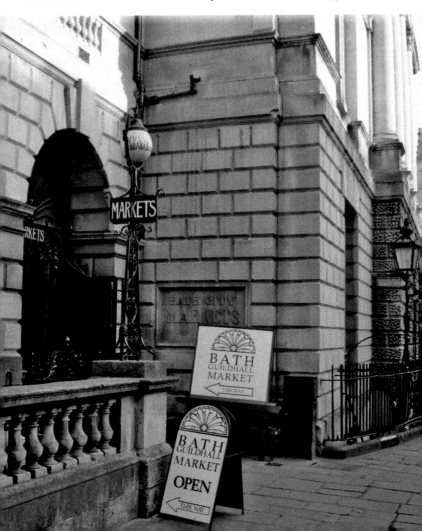

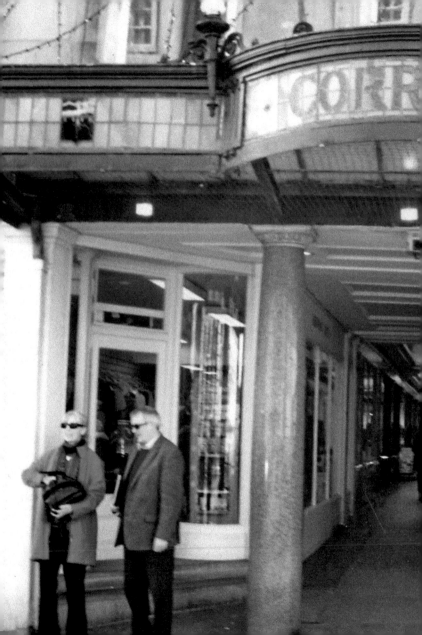

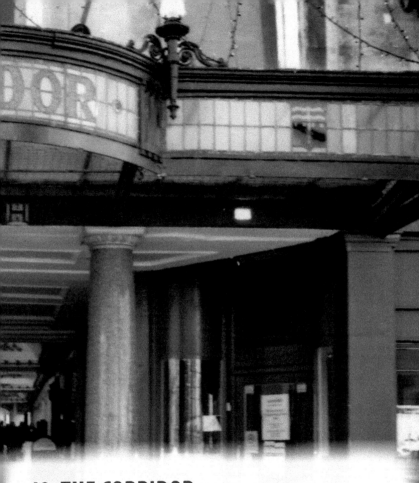

40. THE CORRIDOR

This image of the outside of the walkway, taken in 2012, shows the stylish art deco glass sign with supporting marble columns. Built in 1825 along the lines of London's Burlington Arcade, it is believed to be one of the oldest retail arcades in the country.

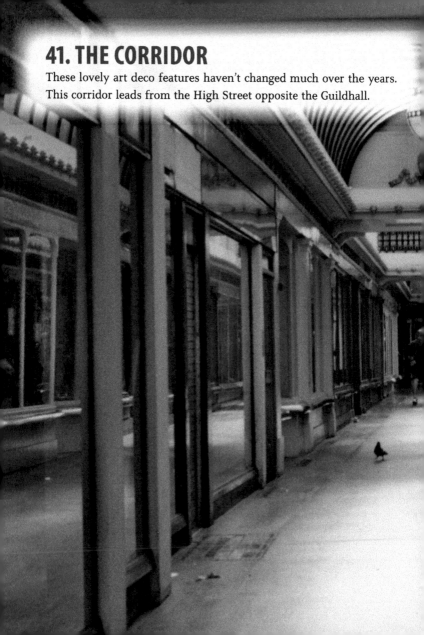

41. THE CORRIDOR

These lovely art deco features haven't changed much over the years. This corridor leads from the High Street opposite the Guildhall.

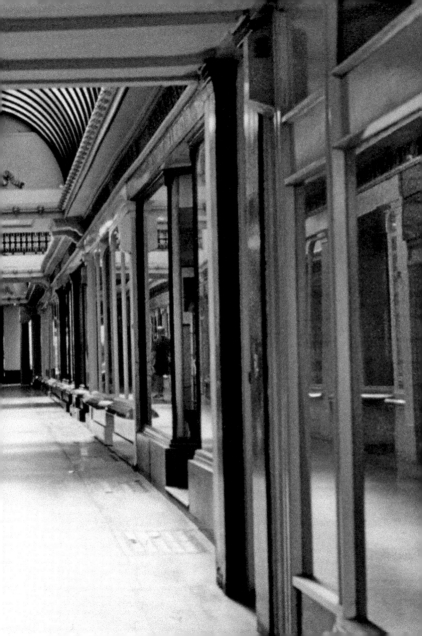

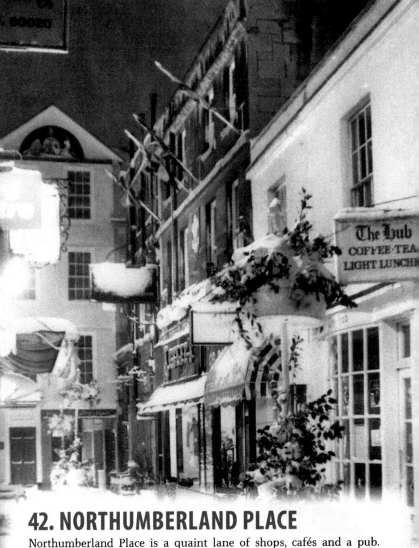

The Hub
COFFEE · TEA
LIGHT LUNCHES

42. NORTHUMBERLAND PLACE

Northumberland Place is a quaint lane of shops, cafés and a pub. It starts in the High Street opposite the Guildhall. The image on the right shows a snow-covered Northumberland Place in 1980.

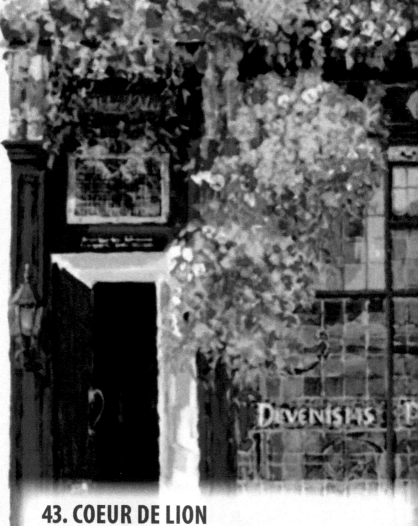

43. COEUR DE LION

This image is from a postcard showing the frontage of the Coeur de Lion pub. In summer there are chairs and tables outside. It is said to be Bath's smallest pub and has a restaurant upstairs.

44. VICTORIA ART GALLERY

The Victoria Art Gallery is on the corner of Bridge Street and opposite Pulteney Bridge. This is a free public art gallery owned by Bath and North East Somerset Council and hosts regular exhibitions run by local volunteers.

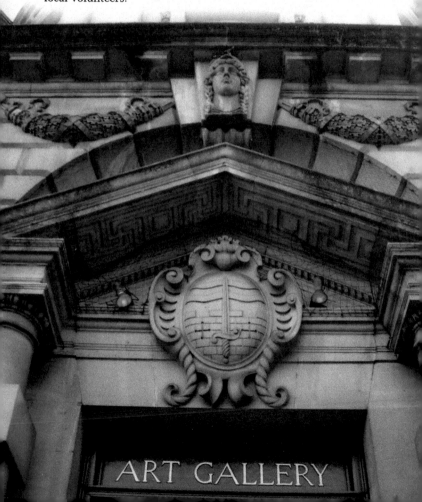

ART GALLERY

45. PULTENEY BRIDGE

Pulteney Bridge was designed by Robert Adam in Palladian style and completed by 1774. In this photo from 2003 canal boats decorated with bunting moor at the bank for the May Bath Festival. Towering in the distance, the former Empire Hotel and Navy Headquarters during the Second World War are now luxury apartments above ground-floor cafés.

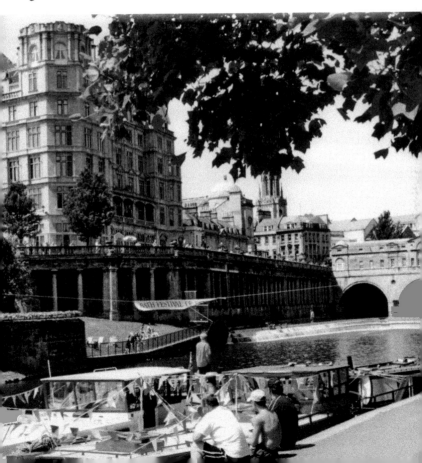

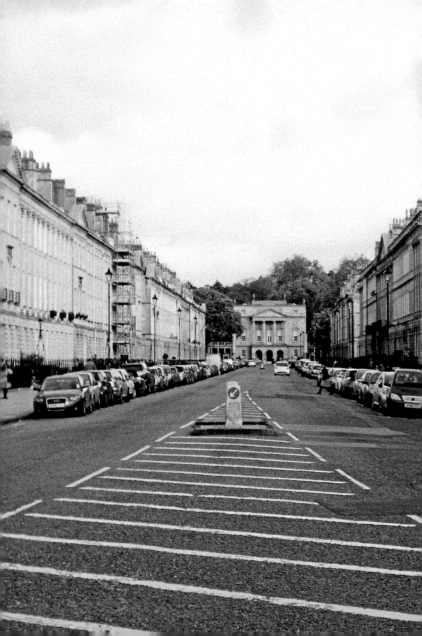

46. GREAT PULTENEY STREET AND HOLBURNE MUSEUM

With your back towards Laura Place Fountain, which you cannot see in this picture, this view is of Great Pulteney Street looking towards the Holburne Museum. This museum houses some of Bath's finest art collections. The fountain at Laura Place sits at the start of Great Pulteney Street and leads to the Holburne Museum at the end. The original fountain was erected in 1877.

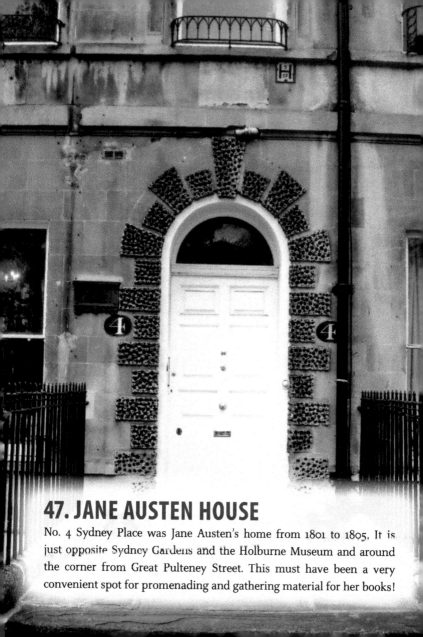

47. JANE AUSTEN HOUSE

No. 4 Sydney Place was Jane Austen's home from 1801 to 1805. It is just opposite Sydney Gardens and the Holburne Museum and around the corner from Great Pulteney Street. This must have been a very convenient spot for promenading and gathering material for her books!

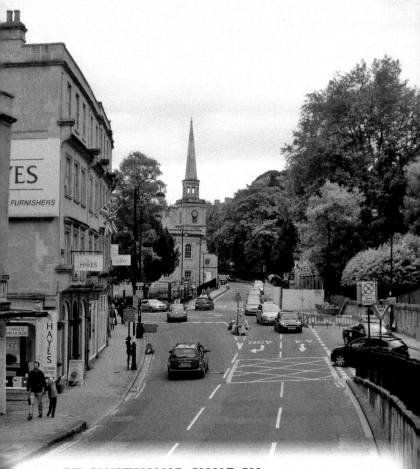

48. ST SWITHIN'S CHURCH

This church is famous for its connection to William Wilberforce, the anti-slavery campaigner. It is situated at the top of Walcot Street and the busy London Road. In 1889 a landslide destroyed three town houses in Camden Crescent opposite the church next to Hedgemead Park.

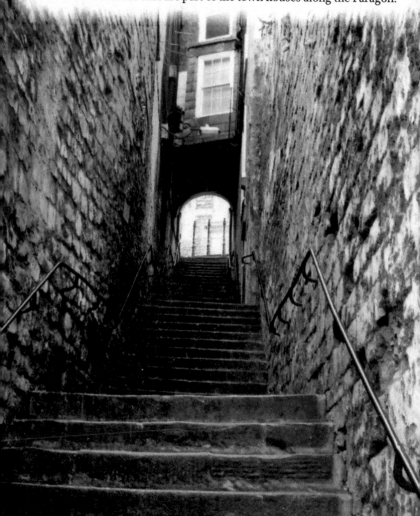

49. WALCOT STREET

These really old steps are a shortcut between Walcot Street and the Paragon above. No space is wasted, and you can see windows above the arch of a house that are part of the town houses along the Paragon.

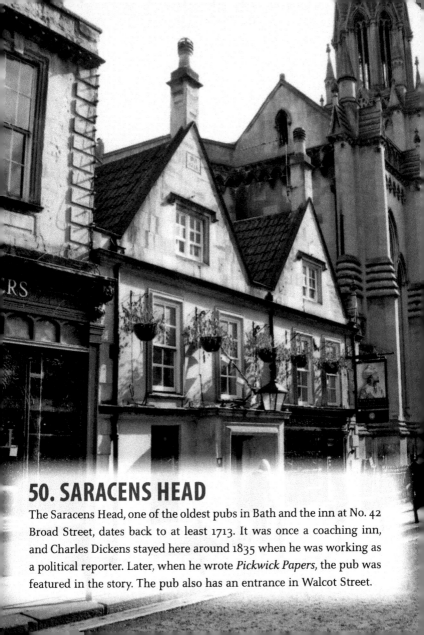

50. SARACENS HEAD

The Saracens Head, one of the oldest pubs in Bath and the inn at No. 42 Broad Street, dates back to at least 1713. It was once a coaching inn, and Charles Dickens stayed here around 1835 when he was working as a political reporter. Later, when he wrote *Pickwick Papers*, the pub was featured in the story. The pub also has an entrance in Walcot Street.

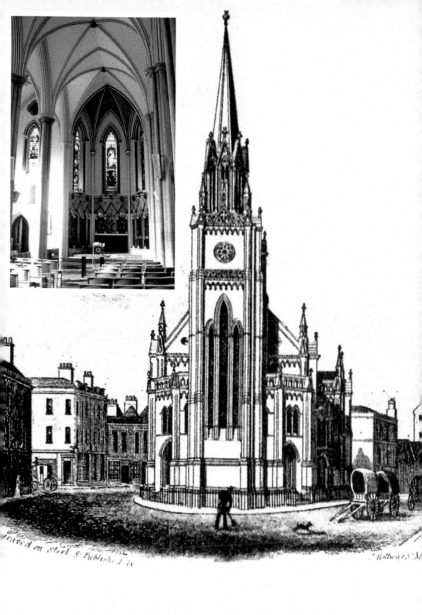

ST MICHAEL'S CHURCH, BATH.

Drawn on Steel & Published by

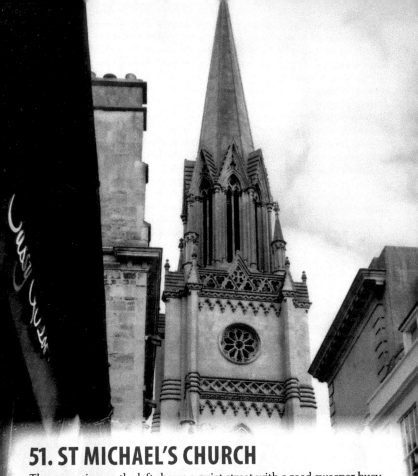

51. ST MICHAEL'S CHURCH

The engraving on the left shows a quiet street with a road sweeper busy at work. St Michael's is located between Broad Street and Walcot Street, both of which merge into Northgate Street in the centre of town. The previous church faced east to west, but when it was rebuilt in 1837 the building then faced north to south in order to face Jerusalem. It now houses a café if you are in need of light refreshments. The inset image shows the attractive interior of St Michael's in 2012.

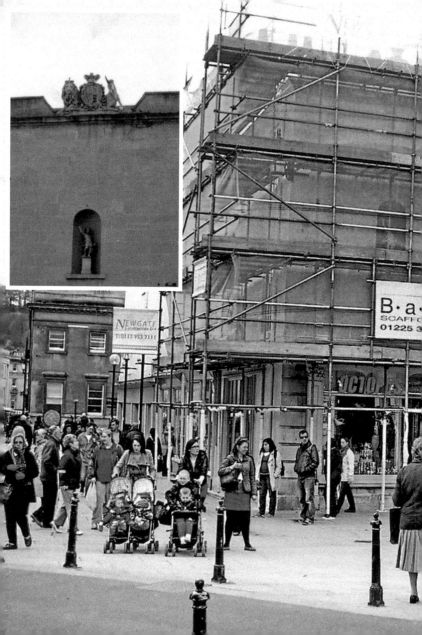

52. MILSOM STREET

Milsom Street is still a meeting place and there is a bench for weary travellers. This picture was taken in 2012 with scaffolding covering the building. Two policemen on horseback are on duty. The inset picture shows the freshly painted lion and unicorn sitting on top of the building.

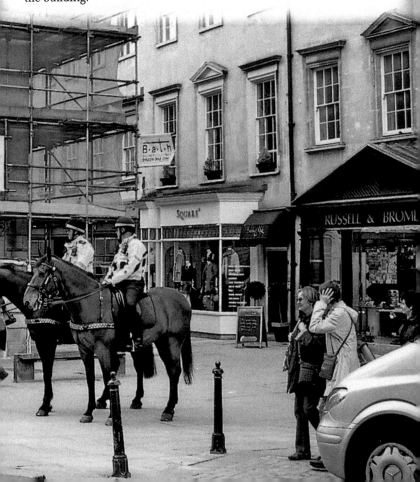

BATH BALLOON

This is a wonderful example of a hot air balloon about to launch in Victoria Park, one of the lovely green spaces in Bath. Victoria Park also houses the Botanical Gardens, a lake, a large children's play area and a statue to Queen Victoria – hence the name Victoria Park.

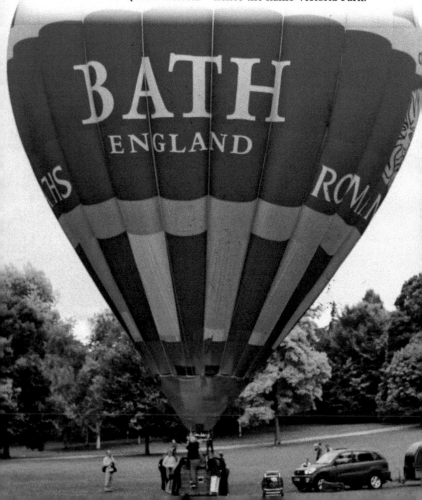